IMAGES
of America

HAMPSTEAD

Hampstead's town charter, signed by Gov. Benning Wentworth, includes this map that goes into great detail on the town boundaries, weaving around homesteads and landmarks such as "John Dustin's Land to the Brook that runs from Emersons mill" and specifying measurements, like "one mile & twentyseven rods to a stake and stone" in a certain direction, to create the Hampstead limits. (Courtesy of the New Hampshire State Archives.)

ON THE COVER: The District 4 school in West Hampstead, one of four remaining one-room schoolhouses in the late 1920s, was led by teacher Doris Spollett. (Courtesy of Sandra Piasecki.)

IMAGES
of America

HAMPSTEAD

The Hampstead Public Library and the
Hampstead Historical Society

ARCADIA
PUBLISHING

Published by Arcadia Publishing
Charleston, South Carolina

Printed in the United States of America

Library of Congress Control Number: 2024931575

For all general information, please contact Arcadia Publishing:
Telephone 843-853-2070
Fax 843-853-0044
E-mail sales@arcadiapublishing.com

Visit us on the Internet at www.arcadiapublishing.com

To Hampstead residents past, present, and future—
particularly during your anniversary celebration years

CONTENTS

Acknowledgments

In 1897, the property at 67 Main Street was built as the Hampstead Public Library, which then became the Hampstead Historical Society in 1994 when the library moved and expanded. We are proud to bring our histories together again with the creation of this book. Many of the images found in these pages have been preserved thanks to the historical society and have been printed with their permission. Any images not specifically credited are from their collection. Special thanks to Virginia Morris and Rob Morris from the Hampstead Historical Society for leading this project for their organization. From the Hampstead Public Library, Julie Watt and Merrily Samuels were instrumental in the creation of this book.

We would like to thank the New Hampshire State Library for lending us their scanner. We would also like to thank Arcadia Publishing and our editor, Caitrin Cunningham, for her guidance and support.

The Hampstead community has been a tremendous help in bringing this book to fruition. We were so excited to see what photographs would be found tucked away in family albums and attics across town, and we couldn't be happier about the outpouring of support we received. Not only did we hear from local individuals and families but also people as far away as North Carolina and Illinois who had Hampstead connections.

In addition to acquiring photos, the memories shared with us were invaluable to piecing this book together. Our favorite conversation was sparked online when we posted a photo of longtime telephone operator Molly Davis and people recounted memories of her from their childhood. One person shared that Molly would babysit him over the phone when he got home from school, while another remembered in first grade picking up the phone to ask Molly where her mom was, and Molly, who always had the answer, reassured the young girl she'd ring her mother who was up the street to send her home.

Special thanks to Betty Boisse Turner, Bonnie Howard Knox, Brad Robie, Jim Wilkinson, and John Kelley for their recollections and help, and many thanks go out to the greater Hampstead community for their contributions.

INTRODUCTION

Images of America: *Hampstead* is a visual history of Hampstead through the 1960s. Although the artifacts and photographs collected in this book start in the mid-1860s, there were inhabitants hundreds of years before that.

The earliest settlers on the land that became Hampstead were the Abenaki who lived on the western shores of Angle Pond and parts of Island Pond. The land was rich in oak timber, walnut, chestnut, maple, elm, pine, and cedar trees. Farming was difficult on the rough soil, but fishing and hunting were in abundance. In 1642, the Massachusetts Bay Colony acquired the area and called it Pentucket before it was renamed Haverhill and Amesbury shortly after.

It is believed the first settlement was in 1728, with the most populous area being the eastern shore of Wash Pond, where a few families by the names of Ford, Heath, and Emerson put down their roots. Around this time, the land once again changed names and was called Timberlane. In 1733, the inhabitants sent a request to the district parish, stating it was too difficult to travel miles to weekly church services, and requested their own place of worship. This request was granted, and a small meeting house was built on what is now Main Street.

It was in 1741 when the boundary between Massachusetts and New Hampshire was established and Timberlane was placed as part of New Hampshire. In 1745, work began on a new meetinghouse, and construction continued until completion in 1748, using hand-hewn timber for the exterior and pine for the interior finish.

In 1746, a committee of three men—Richard Hazen, Daniel Little, and John Webster—were voted to lead the petition to Gov. Benning Wentworth, who owned a residence on Island Pond for a town charter. The first petition was presented on July 29, 1746, and they petitioned again on May 12, 1748. On January 19, 1749, the town, with a population now around 100 and on 8,350 acres of land including three bodies of water, was incorporated and called Hampstead, named after a small hamlet outside of London.

The first town meeting was held on February 7, 1749, in the meetinghouse, and a board of five Selectmen was chosen. The following year, in 1750, it was voted to hire a schoolmaster for six months and start a public school system which led to the creation of a number of district schools throughout town. These districts were partitioned off by stone markers around town with carved-out numbers indicating which school a child would attend if they lived between the bounds, and each school was housed in a one-room structure with eight grades being taught by one teacher. The first so-called social library was recorded in 1796, nearly 100 years before a proper public one was built.

From the first known 12 Rod Road, a 98-foot-wide route that ran from East Hampstead's border with Plaistow north near today's Central Street and ended at the western edge of Angle Pond, until 1800 when a highway tax was imposed, roads were sparse and mostly used for horses and ox carts. This tax meant to expand the roadway was paid in labor, with anyone unable to work being able to hire a stand-in at 8¢ an hour. The need for roads was great, as Hampstead

was an accessible throughline of travel as part of a direct route from Concord, New Hampshire, to Boston, Massachusetts, and on a direct route between Londonderry, New Hampshire, and Newburyport, Massachusetts.

Early Hampstead was an industrious town composed mostly of farms, blacksmith shops, gristmills, sawmills, lumbering, shoe and hat manufacturing. In the late 1700s, hand-wrought nails were made, and it was reported in 1791 by the Selectmen that 100,000 six-penny nails were made by James Shepherd in his workshop, and over the next few years, that number increased.

By 1830, there were 913 inhabitants and industry continued to expand. By 1835, there were five blacksmiths, two gristmills, one sawmill, three large general stores, one large tannery, wagon makers, and wheelwrights. Shoemaking was also a large industry, with many farmers in town constructing small cobbler shops on their properties for the winter months to fill out their work schedules when farming came to a halt. At one time, more than 100 men and women made shoes in their little shops.

In the early 1800s, John D. Ordway began producing palm-leaf hats, so popular at the time that his factory was producing between 30,000 to 40,000 per year with the leaves being imported from Cuba. Ordway employed many women and children in the creation of the hats, making them the largest business in town. His manufacturing was greatly improved by William Johnson of West Hampstead, who invented a machine to split the leaves, which had previously been done by hand. Johnson also had a large orchard that supplied many of the trees around town and shipped his peach trees far and wide, once providing 5,000 of them to California.

Around this time, there were seven school districts, with three made of brick and the other four of wood. In 1835, it was reported that 13 people from Hampstead had already gone on to receive postsecondary education at the likes of Harvard College and Dartmouth College.

In 1849, the centennial was celebrated on July 4 in Davis Grove, which later became Brickett's Grove, with the town deciding it would be better to have the commemoration take place in a warm month instead of on the January incorporation date. Families in town contributed provisions, the grove was decorated with flowers, and a stage was built and adorned with the words "Independence" and "1776" spelled out in roses while "1749" was in white rosebuds. Festivities included music from a band and choir, prayer, and a reading of the town charter.

Now, 175 years later, Hampstead commemorates its 275th anniversary, and we once again celebrate the past with this book. In the upcoming pages, images starting in the mid-1860s are accompanied by captions of actuality and anecdotes, with many highlighting how Hampstead still honors its early roots. History endures in street signs stamped with names like Little and Eastman, nods to Hampstead's first selectmen, George Little, and first town clerk, Peter Eastman, or Depot Road at the western edge of town, marking the area where the train to Boston once ran. It can also be seen in the preservation and usage of historic structures like the Old Meeting House on Emerson Avenue or the former high school, which now houses town hall and whose grounds include an original cobbler shop preserved by the historical society with work benches, tools, and shoe molds still intact.

Although the railroad and palm leaf hats are long gone, Hampstead remains a vibrant and industrious community. We hope that you will enjoy this photographic trip through time.

One

Around Town

At Hampstead's 100th-anniversary celebration in 1849, it was said that the oldest inhabitant of the town was the so-called "royal oak" tree that was believed to have rooted around 1600 and expanded 25 feet in circumference by the time the town was 100. It flourished on land that we know today as Main Street and, at one time, lay hollow as a hiding spot for neighborhood children. As the town grew, its structural footprint expanded to fill in its 13 square miles, growing beyond the central corridor anchored by the Meeting House to the eastern and western corners of town, which were still a landscape of wilderness. In a 1753 account from Peter Morse, who owned a mill at the end of what is today Lewis Lane in East Hampstead, he was tending to a coal pit away from his home one evening when he found himself surrounded by a pack of wolves, causing him to spend the overnight hours throwing firebrands at the wolves to keep them at bay. Despite these hardships, Hampstead was a popular area for early settlers as there were many sources of waterpower to set up mills. Control of the water was granted to the individuals who owned land or to those who bought the water rights, which gave them permission to control the flow by building dams. Outside of these powerful streams, it was even said that one spring of water in town owned by the Emerson family was famous for its medicinal water. As homesteads were built, the land was cultivated, and Hampstead turned into a thriving farming town.

The first cornerstone of the Meeting House was laid in 1745, and it was completed in 1748 before the town's incorporation. Upon completion, the 50-foot-long-by-40-foot-wide structure was used by multiple church denominations and for town meetings, including the first one in February of 1749. There were three small galleries with plank seating, and a pulpit on the back wall stood 11 feet high. Six pillars were installed in 1752, and in 1756, the landowner, George Little, officially deeded the land over to the town. After years of wear and tear, renovations began on the Meeting House in 1792, with the building being painted and a nearly 100-foot tower and steeple added. It would be another few decades of cold winter gatherings before heat was installed. In 1980, the now-historic Old Meeting House was added to the National Register of Historic Places.

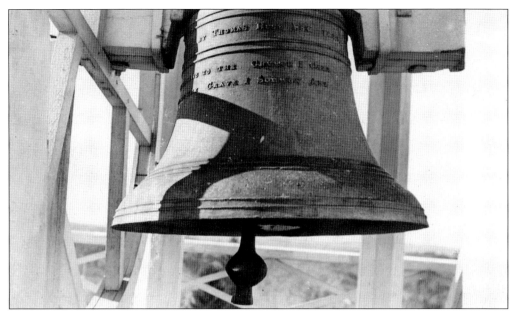

Inscribed with "The living to the church I call, and to the grave I summons all" and labeled "Revere, Boston" (likely in reference to Paul Revere Jr.), the bell at the Meeting House dated 1809 was procured from leading bell maker George Holbrook by Thomas Huse. In the 1800s, the bell was rung at set times to call people to church and for gatherings, and today, it is still rung at midnight on July 4.

A social library provided a small collection of books for nearly a century before the town library opened in 1888 at the home of Willard F. Williams, who was appointed librarian. A proper library, pictured here, was built in 1897 on land purchased on Main Street, and Mary Lillian Hoyt became the new librarian. These libraries and many of the books, which reached nearly 1,500 by 1899, were funded in large part by Nelson Ordway.

Train riders, including a bear, wait for the train to the Rochester Fair (today called the Granite State Fair) at the West Hampstead Railway Depot, located south of Depot Road. The train station was established in 1876 by the Worcester & Nashua Railroad Company and was acquired by the Boston & Maine Railroad in 1906. The train ran from Worcester, Massachusetts, to Portland, Maine, with a crossing in Windham, New Hampshire; therefore, a trip to Boston required switching trains in Windham. During its peak, a freight train could be seen arriving every hour while an additional six to eight passenger trains arrived per day. The station pictured above burned down in 1913, and a new one (below) was constructed in 1915.

The train remained the prime mode of transportation for goods and people to Boston until closing in 1934 when automobiles became the primary source of transportation. The tracks were pulled up in 1937 and sold for scrap while the railroad bed was abandoned for many years before it was turned into recreation trails.

Located at 545 Main Street, the residence in the foreground was built in 1850 by John D. Ordway. The residence in the background belonged to his father, also John D. Ordway. Across the street, John D. Ordway & Son, opened originally by the elder, and taken over in 1860 by his son, was one of the largest and best-known trade merchants in southern New Hampshire.

The Methodist Church in West Hampstead, located at what is now 594 Main Street, was built in the 1880s and dedicated on June 25, 1884. Before that, Methodists would conduct services in private homes and then at schools. The church continued to be an active parish until the late 1970s when it closed.

Angle Pond, referred to in early documentation including the town charter as Angly Pond, expands 161 acres and is surrounded by both Hampstead and Sandown. In its earlier years, this body of water was reported to be a site where some of the Abenaki people once lived and was used in the late 1880s by the Congregational Church for baptisms.

PAVILION AT SUNSET LAKE PARK, HAMPSTEAD, N. H.

In 1926, Lemuel and Ethel Ells purchased 18 acres adjacent to Wash Pond, subdividing it into lots for selling and renting summer cabins. Reference to the pond's more inviting name, Sunset Lake, can be found as early as 1889 in the *Boston Globe*. So, although Ells did not coin the moniker, he did use it in advertisements to sound more appealing, turning it into the more commonly used name. (Courtesy of Jim Wilkinson.)

VIEW OF NORTH SHORE, SUNSET LAKE
HAMPSTEAD, N. H.

21457

The land surrounding Sunset Lake was once farmland, with nine parcels of land making up the waterfront and each plot of land between 22 and 180 acres. The lake first became a tourist attraction in the late 1800s, when summer visitors would board at properties along the water. An icehouse also operated south of the dam on the lake from 1898 until the 1950s.

Beatrice Howard (left) and Frank Howard skate on Wash Pond in 1927. The first reference to Wash Pond dates back to a property deed from 1743. This body of water, enjoyed by many generations of Hampstead residents in both the summer and winter, is more commonly known as Sunset Lake, which it has been called since as early as 1889. (Courtesy of Bonnie Howard Knox.)

From left to right are Hazel Clark, Janice Stevens, Eleanor Clark, and Verna Stevens at the Clark Farm in West Hampstead on March 29, 1932. Eleanor was born in Hampstead in 1920 and lived most of her life in town where she worked for Western Electric for more than 25 years. Her sister Hazel was a year younger than her. The Stevens sisters were family friends who lived in Derry. (Courtesy of Sandra Piasecki.)

Lee Fitts, pictured in the 1920s on skis, lived in East Hampstead and was an active member of the planning board for some years. During the winter season, skiing, sledding, fishing, and ice skating on the lakes were enjoyed, and later people could be seen racing cars on Wash Pond. In the 1950s, there was a ski tow on Garlands Hill off East Road, which was moved to West Hampstead in the early 1960s.

The eastern area of Hampstead borders the towns of Plaistow, Kingston, and Danville. These towns, along with Hampstead, were a part of Massachusetts at one time. This house sat in East Hampstead on what is now Forest Street and has since burned down. The horse and sleigh seen in the picture was a common mode of winter transportation. (Courtesy of Bonnie Howard Knox.)

The formation of the East Hampstead Union Church began on February 18, 1896, when 20 people met at the home of Reverend Ruben E. Bartlett and his wife, Lydia, to discuss a new church in East Hampstead that would welcome a variety of denominations. Not much is known about the construction of the one-story wooden structure with chestnut wood interior finish and a spire, but a little over a year later the church was open and a dedication ceremony was held on April 28, 1897. It sat on one-fifth acre of land, and although a bell was gifted for the steeple for the dedication, it cracked before the ceremony and could not be rung. After the dedication, a meal was served at School District 7 across the street. Reverend Bartlett left the church in 1899, and Rev. John K. Chase became the next pastor.

This section of East Hampstead was known as "the peak." Before the state line was drawn, the land of Hampstead was mostly in Haverhill, but this area was called Amesbury Peak and was part of both Kingston and Amesbury. Pictured in the 1940s, the neighborhood was anchored by a sign directing east and west, while in earlier years, the East Hampstead Union Church, a schoolhouse, Custeau's Supermarket, and a Richfield gas station all populated this crossroad.

This cookbook was published by the Ladies of the Union Church in East Hampstead in 1907 and included recipes for Walnut Ice Cream, Coffee Jelly, Beef Tea Soup, and two recipes for Mustard Pickles. Additionally, ads from local merchants populated the pages, including Irving Leighton, who was a dealer in essences, extracts, and patent medicines, as well as A.S. Little, who advertised himself as "Little, The Butcher."

THE

EAST HAMPSTEAD

COOK BOOK

PUBLISHED BY

THE LADIES OF

THE UNION CHURCH

East Hampstead, N. H.

The ladies wish to thank all those who have
helped in any way to make this book a success.

In the late 1800s, Hampstead had a highway supervisor for each of the three sections of town, a title that was later renamed to road agent. By 1919, thirty streetlights were installed in town, like those seen here in East Hampstead, and in 1924, it was voted to have just one road agent for all of Hampstead.

It was said that 203 East Main Street, built in 1750 by Peter Morse, a signatory on the original petition to incorporate Hampstead and one of the first selectmen, was the first house built in Hampstead. His son, Edmund, and daughter, Judith, were believed to be the first male and female born in the town.

This early-1900s scene shows horse carriages traveling north on Main Street, which was a dirt—and sometimes mud—road. Shop Pond is on the left of this portion of the road. Traveling further north would lead to Sanborn's Blacksmith shop on the left, and straight ahead was the home of Dr. Lake, a prominent Hampstead physician at the turn of the century.

Formally known as the "Island Farm in Perch Pond", the 233-acre island on Island Pond was purchased in April 1741 by Gov. Benning Wentworth the year he became governor of New Hampshire. Wentworth built a mansion on the land and settled into his new political role. He and his heirs owned the island for almost 40 years, with the mansion eventually falling to ruins. The island is now called Governors Island after the former owner.

The first Island Pond camp was built in 1888 and called Camp Pleasant, followed by another four years later built by the Grand Army of the Republic, an organization of Union Civil War soldiers. Summer camps continued to populate the shores, with many eventually converting to year-round residences. In 1956, some children from the extended Grover family had fun at their lakeside summer camp located on Mills Shore Drive on Big Island Pond (left). From left to right are Judy Sylvester, Anne Sylvester, Mabs Mango, and Cecily Mango. The camp's interior is pictured below in the 1950s. (Both, courtesy of Cecily Mango.)

Island Pond, often referred to as Big Island Pond, is shared by Hampstead with the neighboring towns of Derry and Atkinson and sits on nearly 500 acres. In the early 1900s, inventor George Eli Whitney could be seen on the pond giving rides to beachgoers on his steamboat. (Courtesy of Cecily Mango.)

The Bartlett brothers, Bobby (left) and Billy, are pictured on Big Island Pond at the summer camp built by their uncle Frank Leith. The extended family stayed there every summer, and a caretaker lived there year-round, residing in the house during the winter and the barn in the summer. In 1956, their sister Elaine Bartlett David moved into the camp year-round with her family. (Courtesy of Susan David Mancusi.)

The earliest mills were water-powered until the mid-1800s when steam power took over and proved to be more advantageous as it was portable, therefore, business was not limited to one area. In the 1870s, E.E. Currier and Nelson Ordway opened a steam sawmill near the railroad station and bought several lots to cut timber, while in 1872, it was reported that nearly 700,000 board feet of

lumber were sawed in Hampstead. These men and their horses, pictured here, were somewhere in the Angle Pond area and working at a sawmill cutting logs into lumber. The workers are, from left to right, Donald Gates, Fred Martell, Maurice I. Randall Sr., John Woodward, ? George, George Gorton, Charlie Palmer, Bill Bergeron, and George Andrews.

The Hampstead Congregational Church was organized on June 3, 1752, and met in the Meeting House, with 68 members and Rev. Henry True as the first pastor. They erected their own building in 1837, which was replaced less than 30 years later on the same grounds as it stands today. The first Sunday school records date from 1818, but it is believed that they started even earlier.

During Rev. Albert Watson's pastorate at the Congregational Church from 1876 until 1893, nearly 200 new members joined, and at one time his wife served as president of the Ladies' Aid Society, a charitable organization that raised funds for the church. Watson, pictured in the church in 1891, led the town in a prayer at the 150th-anniversary celebration in 1899 and stated that "every man owes himself, his best, to his town." (Courtesy of Brad Robie.)

On Saturday, June 22, 1901, at about 1:30 a.m. the Congregational Church was struck by lightning, with the steeple being a direct hit. The damage resulted in a portion of the steeple being torn away, the south corner of the church being demolished, and multiple windows being torn out. The lightning even passed through the length of the church into the vestry. (Courtesy of Brad Robie.)

This Queen Anne–style home on Main Street across from the Congregational Church was built as a parsonage for the church, with a deed to the Congregational Society of Hampstead for $250 from Arthur and Alice Emerson dated November 8, 1893. The property was then owned by Dr. Walter Allen and Grace Allen in the 1920s and used as both a home and office until he passed in 1938.

Rev. Henry True of the Congregational Church served the parish for 30 years before he passed suddenly on the way to church in 1782. A Harvard graduate, True was 26 years old when he joined the church and, a year later, married Ruth Ayer, the daughter of Deacon James Ayer of Haverhill. This house dates to 1768 when Henry built it for his family of 10 children, and it is one of the oldest in town still standing.

Thomas Huse, who was living in the old Gov. Wentworth house on Island Pond, noted there was a steeple without a bell at the Meeting House, so he set out to change that. After procuring the bell in 1809, the story goes he had it suspended from this old royal oak tree in front of the Parson True House and rang it for the surprised townspeople to hear, as they were unaware a bell had been purchased.

The Congregational Church choir dates back to the mid-1890s when it was formed and replaced the Hampstead Sacred Music Society, which had been in place since 1840. Included in this photograph from the mid-1900s are Maud Stevens, Mable Emerson, Eva Bassett, Ruth Greenwood, Mildred Emerson, Nancy Hutton, Elaine Mansur, Marilyn Whiteneck, Evelyn Emerson, and Dorothy Mansur. (Courtesy of Jan Brickett Howe.)

The Congregational Church (right) and its neighbor the public library were the center of town from the earliest days and into the early 1900s. Sidewalks were laid in the 1800s from the Meeting House to what is now 235 Main Street, connecting to well-trodden areas like the Emerson Shoe Factory where many people worked. The purpose and necessity of the sidewalk was to avoid the mud and manure of the horse-drawn carriages.

This property located at 184 Main Street was historically known as the William Sanborn House. Sanborn was a deacon at the Congregational Church who owned Lakeside Farm and a blacksmith shop on 35 acres of property starting around 1840. William Sanborn and Lois Calef Sanborn's son, John C. Sanborn, next owned the property with his wife, Annie Fitts Sanborn. John and Annie took in summer boarders who stayed in rooms in the main house to take advantage of Island Pond. Later, the property was subdivided into multiple properties, including 178 Main Street and Sanborn Shores, and was owned by families by the name of Fitts and then Nadeau who developed Sanborn Shore Acres campground in the 1960s on the property. (Both, courtesy of Michelle Bernard.)

This image of Main Street in the early 1900s looks north, with the Congregational Church just out of sight on the right. The sign in the middle of the image is believed to be an advertisement for a blacksmith shop.

The tradition of New Hampshire being first in the nation in primaries began in 1920, and residents have taken their civic duty seriously ever since. Here, a sign supporting the US Senate campaign of Wesley Powell, a former New Hampshire governor from 1959 to 1963, sits outside a house on Main Street in 1966. (Courtesy of Bonnie Howard Knox.)

This house, located at 87 Main Street, has been known as both Lakeview and Camelot over the years. The house was built for Dr. George Bennette and his wife, Amelia Bennette, whose name is on the original deed from 1890. The next owner was Lillian Helen Forsaith, a candy manufacturer who bought the property in 1912 and added an additional five-and-a-half acres, extending the land from Main Street down to Sunset Lake. The property remained that size until 1959 when it was subdivided into seven properties. (Courtesy of the Brickett family.)

On August 19, 1943, at 4:30 p.m. a US Army Air Force plane coming from Logan Airport in Boston circled Island Pond with its wheels extended before suddenly going into a spin and crashing into the woods. All five men on board, ages 20 to 25, lost their lives when the plane crashed. This memorial gravestone was placed near the site in their honor.

During early Hampstead winter snowstorms, oxen and horses were used to plow by placing a log on the front of a sled and dragging it over the snow to clear a path. In 1926, Hampstead purchased its first tractor plow to clear the roads which was imperative to automobile travel. In 1947, in the passenger seat of the truck, is Frank C. Howard, who owned Frank Howard Trucking and was a snowplow operator for the state of New Hampshire. Driving the vehicle was his cousin Maurice I. Randall Jr. while his brother Dean C. Howard stood outside the truck. That same year, Hampstead had two major snowstorms; one was in late February, and one in late December, with more than ten inches of snow from each storm.

This view from the top of the Congregational Church belfry in the early 1900s is looking south on Main Street, where Isaac Randall's general store can be seen in the lower-right corner. It was reported by Maurice I. Randall Jr., former town historian and grandson of Isaac Randall, that important Hampstead historical documents were once distributed for safekeeping among the residents living on Main Street so no single fire could destroy them. Over time, these old documents that were often kept in attics could sometimes end up being thrown in the trash, so Maurice and his father before him would walk up and down Main Street before trash day to retrieve any valuable papers before they were collected.

Two

THE PEOPLE
OF HAMPSTEAD

The Abenaki were the first settlers of the land that became Hampstead, including Chief Escumbuit, who was said to have died on a small island on Island Pond, which later became a namesake for him. After incorporation in 1749, the population expanded beyond the initial handful of families, with the 1769 census reporting 664 people in town, and by 1830, that number grew to 913. Records from the town's first century show that generations of familial lineage continued to call Hampstead home, with family names such as Little, Emerson, Brickett, Worthen, Putnam, Ordway, and Kent showing up in town documents from one decade to the next. Another surname, Noyes, can be found as early as 1763, with a descendent Harriette Eliza Noyes, four generations removed from the first Noyes resident, contributing greatly to the preservation of Hampstead by compiling the expansive book *A Memorial of the Town of Hampstead, New Hampshire* in 1899 to record historical and genealogical history. The lineage of another early settler, 1754 Selectman Samuel Hadley, extends beyond Hampstead all the way to the White House when his great-grandson Chester Arthur became president in 1881. The legacy of others was documented both locally and on the national stage, like Hosea Carter, who was born and raised in Hampstead and later became the postmaster in town but in between testified in the trial of Mary Surratt, who was convicted of taking part in the Lincoln assassination. Josiah Eastman, the great-grandson of Declaration of Independence signer Gov. Josiah Bartlett, represented Hampstead in the legislature from 1847 until 1850 and introduced a bill that established public libraries in New Hampshire. The population of Hampstead continued to hold steady until the turn of the 20th century, with 823 people counted in the 1900 census.

In 1907, sisters Abbie (left) and Beatrice Buttrick posed in front of their East Hampstead home where, along with their young brother Carlton, each was born and raised. Before their mother, Mabel Mills Buttrick, married their father, Clinton Buttrick, in 1901, she was the schoolteacher in District 7, where the three children would eventually attend. (Courtesy of Bonnie Howard Knox.)

In the early 20th century, Cecil Mills and his wife, Bessie Grover, owned a property on Wash Pond where members of the Mills, Grover, and Sears families gathered for a group portrait. The spot where this farm once stood on the western shore is now the site of Camp Tel Noar. (Courtesy of Cecily Mango.)

Around 1910, in the image above, two people sit in a horse-drawn freight wagon outside Isaac Randall's barn (left) and general store (right). Randall was born on October 4, 1859, and moved to Hampstead as a young boy where he went through the school system. After graduating from Hampstead High School, Randall worked for John D. Ordway at his general store in West Hampstead for two years before opening his own store across from the Congregational Church. Randall married Alice H. Spollett in 1889, and they had children Eleanor (born 1893), Maurice (born 1895), and Evelyn (born 1899). In addition to owning his store, Randall served as a trustee of the library and as a selectman in 1884 and 1885. The image to the right is a portrait of members of the Randall family taken in 1907.

The Little family settled in Hampstead in the early 1800s, and later generations lived on Kent Farm Road where Linus L.C. Little's wife, Abiah Tewksbury, was born. The family of Linus and Abiah's grandson Adin S. Little and his wife, Fannie Emerson, is pictured in the early 1900s (left). Adin worked as a meat merchant before establishing a general store, was town moderator for 20 years, and was a representative in the state legislature from 1925 to 1928. From left to right are (first row) Adin S., Elizabeth, and Francena; (second row) Adin E., Fannie, and Perry. In the image below, Perry Little Sr. and his wife, Esther, are pictured with their children in 1951. From left to right are (first row) Susan and Mary; (second row) Fran, Perry Jr., Esther, Perry Sr., Elizabeth, and Evelyn. (Left, courtesy of the Brickett family; below, courtesy of Jan Brickett Howe.)

Doris Spollett was born in Hampstead on September 12, 1897, and is pictured here as a young child. Spollett was a schoolteacher in town for 11 years. Later, she built a lifelong career in politics, serving as a town selectman, becoming the fourth woman in the New Hampshire state senate beginning in 1947, was vice-chair of the New Hampshire Republican Party in 1957, and served 13 terms in the state legislature.

Doris Spollett was the fourth generation of her family to live on their West Hampstead farm and was known for her beautiful Christmas decorations, with all in town welcome to drive by to view the festivities. Her barn would be decorated with a large papier-mâché horse and a nativity scene; however, the highlight was a giant star that sat atop the barn's cupola and could be seen from miles away.

In 1908, the first automobile arrived in Hampstead. It was owned by Frank Emerson, an owner of the William A. Emerson and Son Shoe Factory and a selectman in 1897. His wife was active in the Congregational Church as a pianist and organist, and they lived at what is now 81 Main Street, near the library and the Congregational Church.

Donald Fitts Sanborn was born September 13, 1902, to Annie Fitts Sanborn and John C. Sanborn, who became a deacon of the Congregational Church shortly after Donald's birth. When he was almost three months old, Donald was included in the Congregational Church Sunday School Cradle Roll, a list of young children to encourage and nurture in their faith. The church was the first in the state to organize such a list.

Luther Leslie Johnson (right) and his wife, Catherine "Cassie" Nichols Johnson, lived on East Main Street and are seen here in the 1930s. Luther was born in 1868 and lived on this property his entire life farming the land while Cassie, who was born in Nova Scotia, Canada, and immigrated to the United States in the early 1900s, was a homemaker. The home, originally built by Jim Johnson, dates back to the mid-1800s and has been passed down in the Johnson family for generations ever since. At one time, a cobbler shop was added to the structure. The extended Johnson family can be traced back to Hampstead as early as the mid-1700s, when Zackeriah Johnson, Luther's great-great-grandfather, purchased 90 acres of land for 210 pounds. He was a justice of the peace under the king, but despite that, he sent his two sons to fight for the American cause. (Courtesy of Raymond Johnson.)

Mary "Molly" Davis was Hampstead's telephone agent and chief operator from 1907 to 1955. The first telephone system was installed in Hampstead in 1901, with fewer than 10 telephones in town. When the original line became crowded a switchboard was installed in Isaac Randall's store, and then in the home of John Sanborn for night and weekend calls. On November 28, 1907, the switchboard was moved to Molly's residence at 34 Main Street, and at age 27, she became the chief operator, with the Davis home acting as the communication center. Over the years, new switchboards were installed to meet the growing demand. In 1907, there were 30 subscribers, and by her retirement in 1955, there were 264. Her retirement was prompted by the new dial system being brought to Hampstead, which eliminated the need for operators. Molly's legacy was summed up in a 1952 town report that stated "To us, the name Mary Davis, represents a symbol of progress, dependability, and trust."

From left to right are Irene Marshall, Connie Marshall, Leland Marshall, and Virginia Marshall. The Marshalls moved to Hampstead in 1930, where they raised their daughters, who attended both the Hampstead Central School and Hampstead High School. He worked in agriculture, as a milk tester for the state, and as a woodworker, making ladies' heels. She was a homemaker and seamstress. (Courtesy of Virginia Marshall Morris.)

June Torrey sits in the backyard of her family's five-acre homestead with her lambs in 1939. In the early 1930s, June's parents, Al and Hazel Torrey, brought the family to Hampstead for summers and purchased property on Main Street in 1938, where they raised sheep for wool, bred great pyrenees dogs, had a ram and a cow, and grew vegetables. Torrey later married Charles Littlefield III. (Courtesy of the Brickett family.)

On Friday evenings in the 1940s, school-aged children would gather upstairs in the fire station on Emerson Avenue to watch a movie together. The movies were arranged by Ralph Rooney Sr., who screened many favorites of the time, such as Abbott and Costello, from a reel-to-reel projector. These Friday night free movies were sponsored by the Hampstead Men's Club and later the Greater

Hampstead Civic Club, which was established in 1947. This space was also used as a classroom after the first Hampstead Central School burned down and as a meeting place for the selectmen and other town groups, as well as by the community for recreational and family gatherings when a large space was needed.

From left to right are (first row) Donald Schmottlach and L. Thomas Graney; (second row) Norah Morley Hillis, Molly Davis, Rachel Woods Morley, Jennie Belle Davis-Foss, and Alice Burton-Foss-Hillis. Norah, newly engaged to Franklin Wood Hillis, and her mother, Rachel, came to meet her fiancé's grandmother and aunts around 1940. (Courtesy of Gail Witham.)

From left to right are Winifred Dixon, Grace Rowell Clark, and Eleanor Clark. The Clark family owned a general store and post office in West Hampstead during the 1920s and 1930s. Eleanor spent most of her life living in Hampstead and worked for Western Electric for more than 25 years. Pictured here in 1943, mother Grace was 54, and her daughter Eleanor was 23. (Courtesy of Sandra Piasecki.)

Maurice I. Randall Jr. was a lifelong resident of Hampstead. He was born October 11, 1929, to Abbie Buttrick Randall and Maurice I. "Ike" Randall. He graduated from Hampstead High School in 1947, joined the Navy, serving during the Korean War, and in 1954, married Juanita Bethune. Randall Jr. worked as an electrician but also dedicated many years to the town of Hampstead. He was chairman of the Hampstead School Board and a member of the planning board and the Hampstead Fire Department. During Hampstead's 250th anniversary celebration in 1999, Randall was chairman of the anniversary committee and even wore his grandfather Clinton Buttrick's top hat, originally made in West Hampstead in the 1830s, that Buttrick wore as grand marshal of the 200th celebration parade. As the town historian and president of the Hampstead Historical Society, Randall Jr. kept Hampstead's history alive via his book *History of Hampstead New Hampshire*, published in 1999.

On June 28, 1948, a formal dinner and celebration was held for Hampstead business owner Joe Frost. The event, dubbed Joe Frost Day, included a sitdown dinner where Frost was lauded and a musical performance. The women singing in the above image, from left to right, are Dorothy Mansur, Ruth Eastman, unidentified, Nancy Hutton, and Irene Marshall. Doris Spollett can be seen in the foreground with her back to the camera enjoying the performance. In the below image of the dinner, Joe Frost can be seen in the center in front of the jukebox in his black suit, sitting next to Doris Spollett.

John Hutton (right) graduated from Hampstead High School in 1914 and served in World War I. He held public office positions in town for 40 consecutive years. He served as a constable from 1919 to 1925 and was a selectman from 1922 until 1934. He was a member of the Memorial Day committee and trustees of the trust funds, with his longest-held position being 20 years as town moderator, where he was known for using a silver dollar instead of a gavel to get the room's attention. A town report celebrating his retirement said Hutton's "ability to control an audience, his sense of reason and fair play, and his knowledge of human nature" as well as "his undeniable wit, inserted at just the right moment" were factors in his success. Hutton and his wife, Emma Clark Hutton (below), had five children: Phyliss, John, Ruth, Fred, and Nancy.

Proctor Wentworth Sr. (above) moved to Hampstead in 1939 with his wife, Ruth Eastman Wentworth, and their five children: Joyce, Proctor Jr., David, Paul, and Richard. He farmed most of his life, hauled asphalt shingles all over New England, and worked for the railroad in Plaistow/Haverhill cleaning out cars when trains stopped there at night. The family raised chickens, geese, cows, pigs, and other animals on their East Road farm. Some of the Wentworth children and their cousins are pictured in 1942 on the farm (below). From left to right are Paul Wentworth, Proctor Wentworth Jr., John Dodge, Joyce Wentworth, Martha Dodge, David Wentworth, and David Dodge. (Both, courtesy of the Wentworth family.)

Proctor "Proc" Wentworth Jr. was born on April 3, 1934, and was four years old when he moved to Hampstead. He graduated from Hampstead High School in 1953 and married Patricia Zimmerman in 1960. Wentworth served in Korea from 1956 to 1958 then active reserve until 1960 and standby until 1962. He hauled oil, chemicals, and freight across New England, had his own construction business, and was Hampstead's road agent from 1979 until 2004. His license plate that reads, "PROC," has adorned at least four of his vehicles since New Hampshire started offering vanity plates. Below from left to right are Beverly Pomeroy, Marilyn "Sis" Zimmerman, and Patricia Zimmerman. The high schoolers stood dressed up on their way to an event in front of Proc Jr.'s yellow and black Ford convertible. Patricia played basketball, was a letterwoman in cheerleading, and graduated from Pinkerton before marrying Proc Jr. (Both, courtesy of the Wentworth family.)

Clinton Buttrick, who always had a pipe in his mouth, and his four-year-old grandson Dean C. Howard, who wanted to be just like his Grandpa Buttrick, are pictured in 1942. They are standing in front of what was at the time Buttrick's house on Main Street which his grandson eventually bought. Buttrick was married to Mabel Mills, and they raised their children Abbie, Beatrice, and Carlton in Hampstead. The young Howard was the son of Beatrice Buttrick Howard and Frank Howard and was a lifelong Hampstead resident. He graduated from Hampstead High School in 1956, worked as a carpenter and builder, and was involved in town in many ways, including as a member of the volunteer fire department, a selectman, a building inspector, and chairman of the planning board. (Courtesy of Bonnie Howard Knox.)

Dean C. Howard and Ruthena "Fina" Butler Howard celebrate their daughter Bonnie's first birthday. Fina moved to Hampstead in 1953 and while attending Hampstead High School she met her future husband Dean. Fina and Dean were married at the Congregational Church in 1958, and in addition to running Dean C. Howard Construction together, they restored historical homes and buildings in Hampstead. (Courtesy of Bonnie Howard Knox.)

Frank C. Howard was the Town of Hampstead road agent twice: once from 1955 until 1957 and again from 1972 until 1979. In his first town report in 1955, Howard noted how Hampstead had 6 miles of tarred roads and 2.1 miles of gravel roads. He is photographed here in front of his truck during his earlier assignment. (Courtesy of the Howard family.)

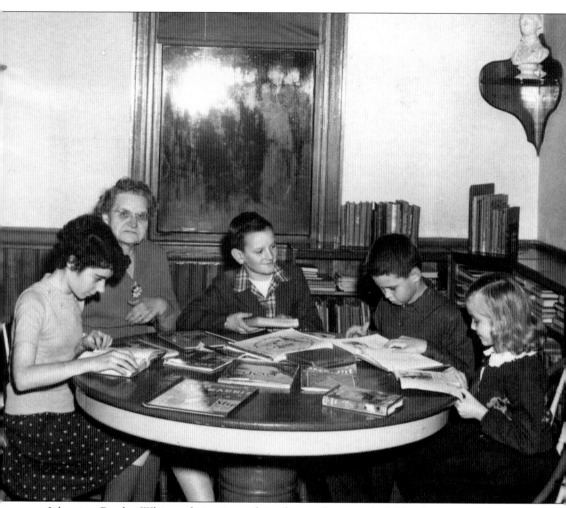

Librarian Bertha Whiteneck is pictured in the newly created children's room of the original Hampstead Public Library in 1955. Her granddaughter Betty Lou Webster is pictured on the right. Whiteneck was the town's sixth and tenth librarian, holding the position from 1942 to 1945 and again from 1951 to 1963. On the urging of the state library, in her first year as a librarian, she cataloged the books in the collection for the first time to make them more easily accessible to the public. During her tenure, it was reported that purchasing books became difficult in the 1940s due to publishers' stock being depleted due to the war, but the library remained active by borrowing books from the New Hampshire State Library and using a bookmobile to provide services around the community and to both the high school and the central school.

Charles Esterbrook was a longtime janitor at Hampstead Central School until a fire destroyed it. On March 3, 1944, the newspaper reported Esterbrook discovered the blaze at 7:15 a.m. before any students had arrived. He approached the building when an explosion shook the ground, causing him to run to the back of the building where he was met with another blast of heat and smoke. He then ran across the street to the fire station and sounded the alarm.

Thorndyke Putnam was born in Hampstead in 1882. He became town ballot clerk at age 21 and went on to serve on the school board, board of selectmen, and the budget committee before becoming the town tax collector for 27 years. He served multiple terms in the state legislature and had many businesses in town over the years, including Hampstead's first car dealership and first taxi service.

A 1953 local chapter of the 4-H group, a national youth organization, gathers for a group photograph. From left to right are (first row) Linda Chesleigh, Norma Blatchford, Lucy Chesleigh (president), Anita Stone, and Mary Joe Stratton; (second row) Judy Stratton, Susan Moore, Jane Wallace (publicity), Cynthia Boisse, Martha Barnes (vice president), Thelma Blatchford (secretary), Joan Chesleigh (treasurer), Caroline Ells, Gail Ritche, Ruth Barnes, and Nancy Biggett.

James "Jim" Burtner was known around town for building his own motorcycles in the big barn on his Main Street property, and he could often be seen riding them around town. His son, David, sits in front of the motorcycle with his hands on the handlebars while their neighbor, John Duston, sits on the back of the bike. Burnter married Virginia Cole Burtner and in addition to their son, David, had a daughter, Nancy. He was in the US Navy from 1948 until 1952 and was a Korean War veteran. He worked at Western Electric Company and Blue Cross and Blue Shield. Burtner was also a former deacon and treasurer of the Congregational Church, and he held positions in town on the trustees of the trust funds and as town auditor. (Courtesy of Nancy Burtner Areano.)

In August 1952, the Hampstead Congregational Church celebrated its bicentennial. To commemorate the occasion, they held a two-day celebration that included a summer sale on the front lawn, a service of worship, a tea at the church, a banquet that included singing and greetings from former ministers, and an anniversary historical program.

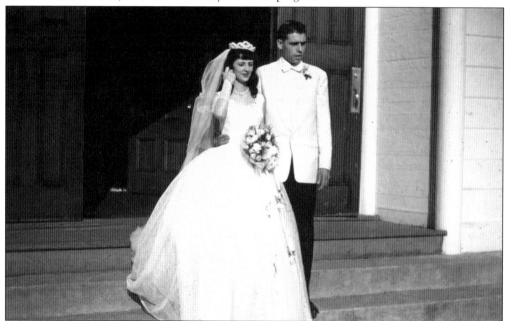

On September 18, 1955, David Wentworth and Nellie June Geisser were married at the Congregational Church. Wentworth grew up on his family's farm and then went to automobile school to become a mechanic, while Geisser was a homemaker to their two children, Betsy and Davey. (Courtesy of the Wentworth family.)

Many young men and women from Hampstead were in the services, and this group of nine just happened to be home at the same time in October 1952 to pose for this group photograph at the funeral of Gordon "Doc" Barthelmess. Barthelmess went to Hampstead High School where he played both basketball and baseball, and after high school, he joined the Navy. Traveling home while on furlough, he was tragically killed in a car accident. From left to right are (first row) Paul Randall, Air Force ROTC, later a lieutenant in the Air Force; and Robert Letoile, who would later go on to join the Army; (second row) William Letoile, stationed in New Jersey; Rudy Curry, stationed in Germany; Maurice I. Randall Jr., sea duty; Huxley White, stationed in Arizona; Robert White, Navy flight duty; Leslie George; and Ralph Rooney, stationed in Alaska.

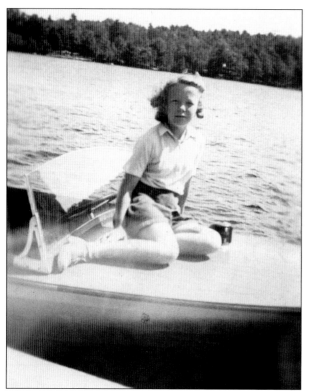

Elaine Bartlett David (left) poses at her uncle Frank Leith's summer property on Island Pond. David was a founder of the Friends of the Hampstead Public Library and created the Hollyhock Thrift Store, which used space in the Congregational Church building next door to the library. When the library moved to 9 Mary E. Clark Drive, a new thrift shop opened, and when David passed away, the shop was renamed the Elaine David Thrift Shop to honor her legacy. Susan David Mancusi (below), Elaine's daughter, is seen at the same Island Pond property in 1962. Susan went on to run the Elaine David Thrift Shop while her son, Nick Mancusi, serves as the president of the Friends of the Library. (Both, courtesy of Susan David Mancusi.)

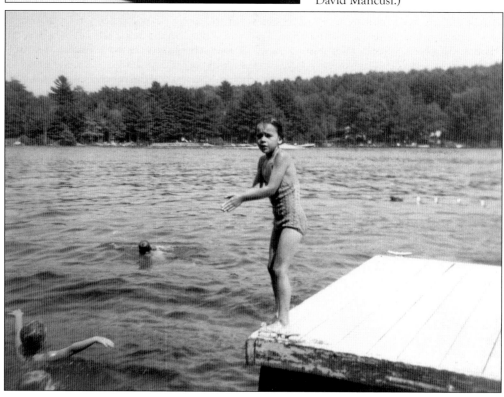

Three

SCHOOL DAYS

At the annual town meeting in 1750, it was voted to "hire a schoolmaster for six months in ye summer season, to teach ye children, to read and write," and in a log schoolhouse, the first Hampstead students began their lessons. In 1752, four school districts were created after funds in the amount of 200 pounds were raised in taxes to support the system. By 1804, there were six school districts, and by 1820, there were eight school districts, with the number of active schools at any given time varying over the years. Each district had one room, and all eight grades were taught by one teacher, with some districts having only a few students and others having up to 40. It was reported that the only reading material available to the schools was the New Testament, which was used to teach reading and writing. Soon after, arithmetic was added, with teachers creating lessons out of daily life examples since no textbooks were available. Eventually, Hampstead purchased nationally published textbooks written by Hampstead brothers Benjamin D. Emerson and Frederick Emerson, with Benjamin authoring the *National Spelling Book and Reader* and Frederick writing *The North American Arithmetic*. The mid-to-late 1800s saw an increasing interest in education from both parents and children alike, with courses covering algebra, history, and surveying being added to the curriculum. Those going on to attend high school went to Atkinson Academy until Benjamin D. Emerson left money to build and maintain Hampstead High School when he passed away in 1872.

Early one-room schoolhouses made do with the resources they had. An 1898 town report noted District 5 schoolhouse had plank seating where children's feet did not touch the ground, making for an uncomfortable day, while another report said a small network of wires had to be stretched from one wall to the other to break up the sound waves since the echo inside the single room made learning difficult.

The School District 2 class of 1923 gathers in front of their schoolhouse which was built in 1851. This was the second schoolhouse used by this district, just down the road from the Meeting House, with the first one being located where the Civil War monument stands. When this school building was no longer needed, it eventually became the Memorial Gym, which is still in use today.

School District 4, built in 1888, was located in West Hampstead on Main Street at the corner of North Salem Road. The large pile of firewood on the side of the building was used to feed a wood stove, the only means of heat inside the building, and students were often tasked with bringing the wood inside.

The District 7 schoolhouse was located in East Hampstead and is pictured here in 1914. The blackboards in this schoolhouse were newly installed in 1899, but as noted by the Board of Education, they were not blackboards, strictly speaking, as they were made of tin with moldings to hold them in place.

In 1872, former Hampstead resident Benjamin D. Emerson willed money to create a high school. Emerson had some stipulations—like that the building had to be built between the Meeting House and "Kent's Farm Road" and sit on more than an acre—and once they were satisfied construction started on the two-story building and Hampstead High School opened its doors on May 4, 1875. The structure was 48 feet long by 38 feet wide and was covered by a slate roof and a 40-foot spire, costing a total of $9,000 to construct. In the beginning, the school ran for 10 weeks, and the first class of students totaled 30 pupils (another request by Emerson was capping the number at 30). Students wishing to attend had to pass an entrance exam and were picked on a quota basis from the districts. Up until 1924, the school week ran from Tuesday to Saturday, at which time the standard was changed to weekends off.

High school principal E.E. Bradley joins his students for a portrait. Bradley was principal for only one year, overseeing the high school in its 13th year. The photograph includes students from the graduating classes of 1886, 1887, and 1888. At the time, subjects that were studied in the high school included physical geography, bookkeeping, composition, botany, moral science, and rhetoric. The invitation is to the 1888 graduation ceremony held at Emerson Hall located on the first floor of the high school and named in honor of Benjamin D. Emerson, the founder of the high school. Graduations were held there for another seven years before moving to the Congregational Church.

The Hampstead High School class of 1914 gathers to take a class photograph. From left to right are (first row) Eleanor Randall, C.P. Quimby (principal), and Florence Hayes; (second row) William Fuller, Clara Keezer, Frank Keezer, Louise Emerson, and Lloyd Hall; (third row) Maurice I. Randall, and Charles Morse. This same year, the first parent-teacher association was formed to encourage more involvement in the school system.

The Hampstead High School class of 1922, including graduates Roy Keeger, Methyl Natino, and Beatrice Buttrick, pose outside the schoolhouse. It would be just three years later that Hampstead High School celebrated its 50th anniversary with a gala event that took place on the grounds of the school and the Meeting House.

CHAMPIONS OF Southern New Hampshire

Hampstead 17
Sanborn 8
Hampstead 24
Pinkerton 17

The 1912 basketball team was the first championship team from the high school, having defeated Sanborn Seminary in Kingston, and Pinkerton Academy in Derry, to give them the title of "Champions of Southern New Hampshire." Two years later, in 1914, basketball paused when it became necessary for the high school to use the lower floor where basketball was played for additional classrooms. Principal C.P. Quimby, pictured here, had only graduated from Bates College in 1910, just two years before becoming the high school's principal, a position he held for only two years.

The 1904–1905 high school boys' baseball team is pictured. In 1903 a teacher was hired to assist the principal who had been the only instructor until then, which led to increased extracurricular activity at the high school. That year, the baseball team competed with nearby Atkinson Academy, and boys' and girls' basketball teams were established only a little over 10 years after the sport was invented.

The 1931 Hampstead High School basketball team poses for a group photograph. In 1914, the basketball court at the high school was eliminated and turned into a space for seventh- and eighth-grade students. The team started back up again in 1931 when money was raised, and Thorndyke Putnam donated labor to rebuild the old District 2 schoolhouse into the Emerson Gymnasium.

By 1934, high school attendance and graduation rose so much that the superintendent's report noted that "today the child that does not go through high school is the exception, as in former times, those that did complete high school were the exception." That year, there were 47 students over four grades and the school won the state championship in spelling.

Elizabeth C. Little is pictured for her senior portrait as part of the Hampstead High School graduating class of 1927. She was one of eight graduates that year and one of two to enter post-secondary school, as she was accepted to study at the Boston Conservatory of Music. A few years after graduating, she was the organist at the Congregational Church.

Published by J. R. Frost Central School, Hampstead, N. H.

As early as 1908, there was mention of consolidating the smaller schoolhouses into one larger school, but it was not until 1930 that the original Hampstead Central School (above) was built. Approximately 180 children in grades one through six came together with the opening of the school, while seventh and eighth grades attended the high school. Children who lived within a mile of school walked, while those farther away rode a school bus. A music teacher and a nurse came to school once a week and were shared with four area towns. On March 3, 1944, a fire burned the building down. World War II limited supplies, but a new central school (below) was built for $37,000 and opened just two years later in February 1946 with four classrooms, a recreation room, and various offices.

In 1948, students gathered at the new Hampstead Central School with school officials to celebrate the first day of the hot lunch program. Equipment for a kitchen and dining room was procured, and more than 116 students out of the 156 enrolled in school were served a hot meal. Attending were Superintendent I. Munro Grandy, Principal David Greenlaw, third- and fourth-grade teacher Beatrice Reynolds, fifth- and sixth-grade teacher Lora Sinskie, seventh-and eighth-grade teacher Alice Davidson, and Jessie Soule, who was the school nurse. This program was overseen by Irma Coombs, who was funded by the Parent Teacher Association and aided by Bertha Whiteneck during the first year.

Teacher Beatrice Reynolds, who taught both fourth and fifth grade at the central school, is pictured with her fourth-grade class. In the school year ending in 1946, she taught 17 boys and 15 girls between the two grades, and her students created a Citizenship Club where leaders were appointed for general school management positions like playground supervisor, health inspector, and housekeeper. (Courtesy of Marie Lagasse.)

School District 6 was located on Central Street where today's Monroe Drive is as early as 1801. At some point later, this building was used as a Methodist church, and then it was deeded to Mary Clark and four other incorporators for a community building in 1919. The sign above the window reads East Hampstead Community Association.

John Parlin (second row, center right) participated in school plays and community plays performed at the Meeting House. His senior year at Hampstead High School in 1931, he acted in *It Happened In June*, a comedy by Eugene G. Hafer. Some of the other performers that year included Eileen Bickford, Edith Wilson, Priscilla Davis, Ada Tait, and Glendon Emerson.

This 1954 fashion show was sponsored by the Parent Teacher Association and featured students who modeled outfits inspired by different eras. From left to right are Kay Kelly, Erva Duston, Glenda Emerson, Virginia Marshall, Sylvia ?, Betty Boisse, and Ruthena Butler. (Courtesy of Virginia Marshall Morris.)

Pictured here are the 1950-1951 girls' and boys' basketball teams at the dedication of the new Veterans' Memorial Auditorium (known as the Memorial Gym). This new gymnasium was the second time that the former School District 2 building had been remodeled, as it was the Emerson Gymnasium from 1932 until 1950. The new Memorial Gym was built for $9,800, with $2,000

being donated by the Civic Club, $2,000 coming from public donations, and materials and labor in the form of roofing, electrical wiring, and painting being donated and done by volunteers. Work started in June 1950, the structure was completed in November, and the dedication was held on December 9. A game between the current high school teams and alumni was played to celebrate.

The Hampstead High School class of 1944 consisted of, from left to right, Lillian Gorton, Charles E. Garland, and Virginia Follansbee. In 1943, the school board voted to close Hampstead High School and provide transportation to Haverhill High School in Massachusetts, due to a teacher shortage. After Pearl Harbor, it was reported that 200,000 teachers left the profession across the United States and that teachers' college enrollment dropped 60 percent.

School board member Charlie Clark presents graduate Ralph Rooney Jr. with his diploma at the 1949 Hampstead High School graduation. The graduation ceremony was held at the Congregational Church. Other graduates from left to right are Paul Randall, Leslie George, Claire Beaudoin, Nancy Hutton, Stanley Modean, Warren Sullivan, and Rudy Curry.

Robert Letoile (left) and Dorothy Mansur were both raised in Hampstead and are pictured before Hampstead High School's 1951 prom. Four years later, in August 1955, the two were married at the Congregational Church. Robert was the co-owner of D&L Builders, was fire chief for three years, and in 1974 he served as general chairman of the town's 225th anniversary celebration. (Courtesy of the Letoile family.)

The annual senior class trip each spring included stops in Washington, DC, and New York City, where the class of 1955 posed at the top of the Empire State Building. From left to right are (first row) Connie Buttrick, Marie Collette, Carol Collins, Virginia Marshall, Betty Boisse, and Ozzie Butler; (second row) Glenda Emerson, Kaye Kelly, Erva Duston, and Eleanor Houston (chaperone); third row Bill Komenda, David Greenlaw (principal), and Donald Brickett.

Betty Boisse (left) poses in front of her Main Street home in her Hampstead High School class of 1955 graduation cap and gown. Betty moved to Hampstead in 1948 and would go on to attend Becker College before marrying Robert Turner of Haverhill, Massachusetts. They raised their four children in Hampstead, where Betty and Bob continue to live. Also graduating in 1955, Virginia Marshall (below) is pictured during her senior year. After completing high school, she worked for Western Electric and soon married David Morris who was studying at the University of New Hampshire. Betty and Ginny were part of the final few classes to graduate from Hampstead High School. (Left, courtesy of Elizabeth Boisse Turner; below, courtesy of Virginia Marshall Morris.)

In 1958, the girls basketball team suited up for another season. From left to right are (first row) Catherine Ayer, Anita Stone, Beverly Pomeroy, Marie Purcell, Martha Barnes, and Patricia Zimmerman; (second row) Frances Kenny, Mary Stratton, Cynthia Boisse, Joan Chesleigh, Caroline Ells, and coach Eleanor Nadeau.

Patricia Zimmerman (left) and Beverly Pomeroy began high school in Hampstead but graduated from Pinkerton Academy in 1960 after Hampstead closed the high school and began tuitioning students to the semi-private school in Derry, New Hampshire. The two friends, who met sophomore year riding the bus to school, pose in their white caps and gowns before heading off to the graduation ceremony. (Courtesy of the Wentworth family.)

The town auditors, Irene W. Brickett (left) and Stanley P. Johnson, pictured here in 1955, were also elected as the district auditors for the school which was an annually elected position. That year, they were each paid $20 for their services to the town and $3 each for their services to the school district.

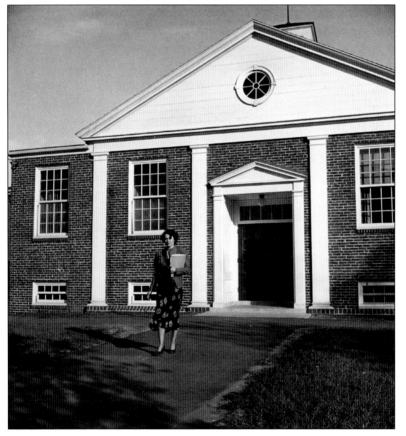

The first recorded school board was in 1801, and there were fluctuations in how many board members were seated until 1886 when a board of three was elected, with one serving a single one-year term, another a two-year term, and the third a three-year term, so a seat would open each year. School board member Arlene Sunanday, who held that position from 1948 until 1952, is seen here walking outside the Hampstead Central School.

Four

BUSINESSES

The manufacturing of goods has been well documented in the early years of Hampstead. In addition to farms, blacksmith shops, mills, and shoe and hat manufacturing, there was a large tannery, a bark mill, a fulling mill, carpenters, masons, spinners, weavers, tailors, wagon makers, and wheelwrights. Mills were aplenty along little streams, with Hogghill Mill, Honeyball Mill, and East Hampstead's Morse's Mill all being written about in the early 1700s. When postal routes were established in 1791, Hampstead was included in one of the four routes in the state which contributed to the town's growth. Small general stores made way for much larger ones, like the shop run by John D. Ordway, which first sold goods from a small table but soon expanded into one of the largest and best-known merchants in the southern part of the state by 1830. Informal taverns cropped up in Hampstead homes as well, where rooms would be rented out to travelers who needed a place to rest with a common area and bar to gather. One such location, Hutchens Tavern, was built on the main 12 Rod Road in the mid-1700s and was later owned by Caleb Harriman, who hosted hundreds of traders on their way from the northern part of the state to seaport towns and even saw poet Henry David Thoreau stay over on his way to Haverhill. In 1837, it was noted there was a lawyer in town, Isaiah Moody, who graduated from Bowdoin College, and doctors of whom there were many, although none had medical degrees and instead were members of the New Hampshire Medical Society.

Isaac Smith was one of the leading merchants in Hampstead for nearly 50 years, founding this general store located opposite the Congregational Church in 1824 under the name Major Isaac Smith & Sons. The store stayed in business in this location for nearly 100 years, passing through multiple owners who each became the town postmaster. Smith sold it to Alfred W. Foote, who then sold it to his brother-in-law Isaac Randall in 1895. In 1916, Joseph Frost, who was a clerk at Randall's store, bought the business from him. The image above of the exterior of the general store was taken in 1898, and the below image of the interior is from 1905, both taken during Randall's ownership. From left to right in the below image are Guy Foote, Joe Frost, and Isaac Randall.

One year after Joseph Frost bought Isaac Randall's general store it was destroyed in a fire on June 1, 1917. Moving quickly, Frost was able to rebuild and open a new building to run his Joseph R. Frost Store and Post Office. He is seen here taking inventory of his stock, which provided both staples and novelties, with one of his 1942 ads giving top advertising space to Snider Catsup and the new Anti-Sneeze Rinso. Frost also published a series of postcards with picturesque images of Hampstead, including the ponds and local businesses. He held the position of postmaster until 1946. When he retired, Lewis C. Darling bought the store and became postmaster, and the store was renamed Darling's Store.

I. RANDALL,
DEALER IN

Groceries, Boots, Shoes, Dry Goods,

HARDWARE, NOTIONS, PATENT MEDICINES,
EXTRACTS, CONFECTIONERY AND CIGARS,
FLOUR, GRAIN AND HAY,
HAMPSTEAD, N. H.

In addition to running the Hampstead general store and post office, Isaac Randall also opened a branch of the store in East Hampstead. This ad showed the wide range of goods offered in his store. In 1903, Randall also entered into a new business venture as a wholesale dealer in lumber and wood.

Spollett's Store and Post Office, West Hampstead, N. H.

In the early 1800s, John D. Ordway established the general store John D. Ordway & Son in West Hampstead and his family ran it for several decades. This general store and post office was eventually taken over by Arthur J. Spollett in the late 1800s and was in operation under Spollett until around 1920. Spollett was married to Carrie Richardson, and they had one daughter, Doris Spollett.

Adele Collins was the first recorded postmaster of the East Hampstead post office at 187 East Main Street, a position she held during the first half of the 1920s. E.W. Cook then took over the general store and became postmaster starting in 1927 until the late 1930s. The general store had gasoline pumps and, in the 1920s and 1930s, included a small restaurant and ice cream parlor called the Cookie Jar.

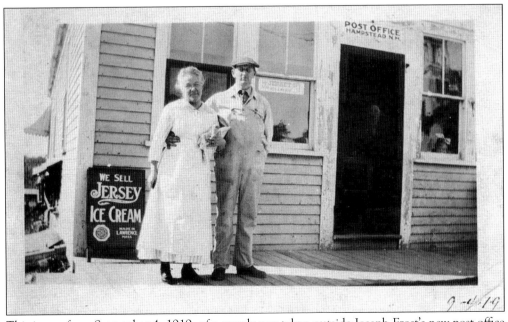

This image from September 4, 1919, of a couple was taken outside Joseph Frost's new post office and general store which was built after the previous one burned down. An ad for Jersey Ice Cream from that time, which Frost sold in his store, stated that its ice cream could only be "found in the stores of up-to-date, wide-awake dealers."

Another general store and post office was located on the northeast corner of Main Street and Depot Road in West Hampstead. Ed Clark and his wife, Grace Rowell Clark, pictured, owned it during the 1920s and 1930s. This small general store, which also had a gas pump, burned down in the late 1930s. (Courtesy of Sandra Piasecki.)

This home was built by Caleb Heath in 1737 and was once called the Gilman Inn. It operated from 1894 until 1929, and many of the boarders who stayed at the Inn were employees of the nearby Emerson Shoe Factory. Later, the house was owned by Levi and Myrtis Duston, who ran multiple businesses. They sold vegetables from their farm, as well as ice and heating oil. (Courtesy of Katherine Brick.)

This home at 185 Main Street was built by Ebenezer Hale in 1753 and operated as Roger's Tavern in the early 1800s and later as Marshall's Tavern. It was also the home of a few Hampstead physicians, including John Bond, James Knight, and Joseph Stull.

The property 361 Main Street was built in 1790 and was once called Taylor's Tavern. Town folklore stated that there was a jail in the basement to be used as a sleep-it-off room for drunkards or for people traveling through town with a criminal to have somewhere to stay overnight; however, it was most likely only a root cellar to preserve vegetables and other goods throughout the winter.

Pictured is a typical horse-drawn hay wagon used on a farm. Farms flourished in the early 1900s, and the milk industry in Hampstead was bolstered by the train station, which was one of a handful of rural stations in the state that had a milk house and milk platform. The seven-by-twelve-foot structure stored milk and was attached to a platform for easier loading onto trains for shipments to Boston.

William Sanborn's blacksmith shop was located on his property at 184 Main Street to the left of his main house on what is now 178 Main Street. Signs on the building include one for the Nashua State Fair and one for ladies' outfitters. There is still an old stone wheel and pipe on the southeast corner of the property that was part of the blacksmith operation.

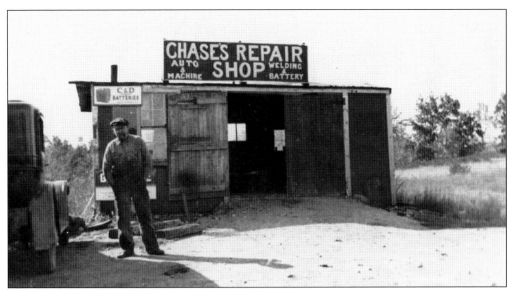

Difficult times swept the country during the Great Depression. George Chase did welding repairs on town vehicles and local farm machinery at his repair shop during that time. He and his wife, Viola Dudley Chase, lived in East Hampstead, and Viola cultivated and sold large volumes of home-grown vegetables. During this time, the Works Project Administration (WPA) under President Roosevelt created labor jobs, which led to many of Hampstead's roads being rebuilt.

In the 1930s, hanging this sign in a window signaled the need for a delivery from Levi Duston's ice business. In addition to being a business owner, Duston was fire warden in the 1940s, and one day when he was out his wife, Myrtis Duston, answered a call regarding an active fire. She proceeded to load their portable fire pumps, brooms, and mattock into one of their ice trucks, rounded up the men on call, and sent driver Frank Howard off with the equipment.

The Liberty Inn was a boardinghouse and restaurant located at what is today the intersection of 121A and 111 in East Hampstead. A 1950 ad in the *Boston Globe* for the inn advertised it as a "perfect spot for a perfect vacation" full of "bathing, boating, fishing, all sports, fine foods" for a weekly room and board rate of $30. The property also included a duck pond surrounded by small cabins that were used for guests, and in the winter, when the pond froze over, it became a popular spot for local kids to skate. At one time, there was also a barn on the property that burned down. The inn was originally operated by Richard and Mary Liberty followed by a succession of owners before it was torn down.

Hotel Winthrop, East Hampstead, N. H. Hand Colored

Dating back to 1810, the current 220 East Main Street was historically known as the Carter Homestead. After Hosea Carter lived there his daughter, Susie Carter Norman, and her husband, Joseph G. Norman, turned it into a tavern and took in boarders. In the early 1920s, William and Jessie Clark turned it into the Winthrop Inn, pictured here in 1935, where they rented rooms and ran a restaurant until the late 1940s. Later, it became the Winthrop Nursing Home.

This home was built by John Dana Ordway in 1850 and is pictured in 1900. He lived there with his first wife, Louisa Kent Ordway, and their five children. It was then the residence of Ordway and his second wife, Martha Sanborn Ordway. She willed a parcel of land to the town upon her passing which became Ordway Park. This home was later turned into the Stillmeadow Bed and Breakfast. (Courtesy of Margaret and William Mitchell.)

Led by Clinton and Mabel, the Buttrick family ran a greenhouse on their property at 206 East Main Street starting in 1924. The greenhouse sat detached from their main residence, and a little shop was on the road where they sold flowers, vegetables, eggs, and chickens. In the late 1940s, both the business and their home were sold to George Chase, a former selectman, who continued to operate the greenhouse until at least the late 1950s. The Emerson family also had a large greenhouse in town. Albion Emerson first managed it before it was taken over in the 1930s and 1940s by Glendon Emerson, the son of Albion and Mary Emerson. Their greenhouse was located on Emerson Avenue near Wash Pond Road behind their home. (Courtesy of Bonnie Knox.)

Smith & Brickett was the first shoe factory to open in 1850 across from the Congregational Church in a three-and-a-half-story building at what is now 66 Main Street. Operated by Nathaniel Smith and Richard Brickett, by 1870, they were employing 40 men, 12 women, and 4 children, and in 1872, it was reported that there were 75,000 shoes and boots manufactured annually. The Smith & Brickett factory burned down in 1884, ending the business. By 1880, another large manufacturer, Charles Hoyt, was producing 120,000 pairs of shoes per year and paying employees between $1.40 and $2 each day. In 1898, William A. Emerson & Son shoe factory opened a large factory on the northwest side of Shop Pond and became one of the largest employers in town.

Having outgrown a smaller building, this two-story shoe factory owned by William Emerson opened in 1898 on the northwest side of Shop Pond on Main Street. At the time, the shoe factory manufactured mostly ladies' shoes and was the largest employer in Hampstead until the Great Depression changed that, closing the once-thriving factory in 1934. The building was then used as a shoe factory by George Ayer and Son until the late 1930s, followed by a poultry business up through the 1950s. The building burned down in March 1959 when it was vacant. The fire was considered suspicious.

One of the earliest documented shoemakers in town comes from a record around 1725 noting John Keazar did his shoemaking in a tent on his property. In the early 1800s, farmers went barefoot in the summer but needed strong shoes and boots for winter work. This led to an industry boom, with shoemakers working in their own homes and later in small cobbler shops built on their properties. These small shops ranged in size, with some seating one or two workers and others up to ten. A large shoe factory in nearby Haverhill also contracted out these small operation cobbler shops to fulfill their quota. In 1849, it was reported in a pamphlet that there were nearly 100 shoemakers in town, but by 1899, it was reported that only about 20 independent cobblers still produced shoes outside of the larger factories. (Courtesy of the Howard family.)

Howard's Garage was built in 1945 by Frank E. Howard. Located at 40 Stage Road, the land on which the garage was built was once part of a much larger estate owned by Nathan Johnson, a selectman in 1873 and 1874, which was deeded to the Fitts family in 1894 who sold a 100-by-100-foot parcel from their lot to Howard for his garage. In addition to operating his business, Howard was also fire chief from 1949 until 1952. Howard's wife, Beatrice Howard, was a homemaker, raising their two sons, Frank C. Howard and Dean Howard, and volunteering for the fire department as one of the red phone operators. The garage was sold to William and Jacqueline Young in 1951 and then to William and Estelle David in 1971. From left to right are two unidentified persons, Frank E. Howard, and Beatrice Buttrick Howard. (Courtesy of Bonnie Howard Knox.)

The local barbershop called Gaudreau's is pictured in the 1950s. It was located at 212 Main Street and had two barbers available to give cuts. In the photograph on the right, Harry Sunanday is seen getting his hair cut. In the 1950s, the barbershop was only open on Wednesdays, so Sunanday could be stopping by before attending that night's planning board meeting. At the time, there were two other locations for Gaudreau's Barber Shop: one in Hampton Beach, New Hampshire, and another in Haverhill, Massachusetts. The Hampton Beach location was slightly bigger, with six barbers on staff, while the Massachusetts location was much larger with ten barbers.

In the 1920s, Harold Brickett and Wesley Collins owned a grocery store on Main Street which was previously operated by Thorndyke Putnam. Then, in 1931, Brickett bought what was formally School District 3 at 219 Main Street from the town and opened his IGA, a franchise of the Independent Grocers Alliance (above). Brickett's IGA grocery store and gas pump stayed in business until about 1950 when Brickett partnered with Harold Shedd and changed the name to Boston Beef Co. In the below image, from left to right, are Alfred Brickett, Irene Brickett, Ken Clark, unidentified, and Harold Brickett. (Both, courtesy of the Brickett family.)

Harold Brickett (left) is behind the counter at his Boston Beef Co., which stayed in business until 1959 when it was sold to Donald Duston. Duston turned it into Don't Market, expanding the building and running it with his wife, Virginia Green Duston, until 1970. Lifelong resident Duston was a land historian and environmentalist, advocating for new streets to have historically significant names, like Wheelwright Road and Kent Farm Road, and dedicating his time to researching deeds for the Conservation Commission to acquire and protect land. In 1959, he and his brother, Harold Duston, started Sunset Park Campground. In the image to the right, Mildred Emerson pushes her shopping cart down an aisle at the shop.

This home located on today's Emerson Avenue was built in 1804 and housed generations of the Emerson family up until the 1960s. John and Betsey Nichols Emerson raised their family there, followed by their son Jesse Emery Emerson, who eventually passed it on to his son Alfred Perry Emerson, who was born in 1841. Alfred and his wife, Sarah Dimond Emerson, raised their eight children in the home, and in the late 1880s, they took in boarders and called the house Hawthorne Lodge, with ads selling the experience of enjoying pure air and fresh farm fare. The property also bore a sign that read Pine Grove Farm, and the family grew berries and vegetables and raised chicken and cows on the farm. Eventually, Alfred and Sarah's sons Albion and Jesse divided the home in two and both lived there with their families.

Howard Wilson (left) and Carl Bullis worked for Stake & Stone Farm as farmhands. Multiple farmhands were needed to support a working farm, and it was common in the 1940s for farmhands to take low pay and primarily work for room and board.

Richard "Dick" Wood lived on Kent Farm Road and was one of the first farmers to have a hay baler. He often baled hay on surrounding farms after finishing his own crops. He is seen here baling at Stake and Stone Farm in the early 1950s.

Howard Wilson is pictured feeding chickens in West Hampstead. Many local farmers went into the poultry business in the 1940s and 1950s. Market and hatching eggs accounted for the bulk of the state's output, with southeastern New Hampshire being the major commercial area of production as it contained sizable processing plants.

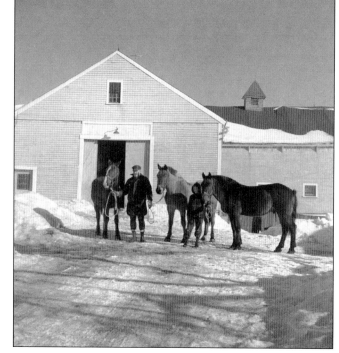

In the 1940s, it was still common to see draft horses like these workhorses bred to work on a farm. In later years, they were replaced with tractors to plow and haul large loads. These horses are about to be harnessed to begin their day, most likely to clear snow.

Harry Sunanday (below) is doing chores at Stake & Stone Farm, the farm he became owner of in 1945. His wife, Arlene, is pictured with a newborn lamb. In the 1950s the Sunandays had 111 Hampshire sheep, which they raised on their farm for showing and breeding and for meat. After World War II, surplus Jeeps were readily available and were found to be useful around farms. The Sunandays eventually sold Stake & Stone to Hampstead resident Dave Morris, who became a founding member of the Hampstead Ski Club, which operated a rope tow at the farm powered by a 1950s Chevy motor. Rob Morris, the son of Dave and Virginia Marshall Morris, followed in his father's footsteps and took over the farm.

Dr. Josiah C. Eastman lived at 167 Main Street and held many positions in Hampstead, including superintendent of schools and library trustee. He graduated from Dartmouth College in 1837 and practiced medicine in Hampstead from 1839 until his death in 1897 at 86 years old. He was president of the New Hampshire Medical Society in 1860, and as a director of the Nashua & Rochester Railroad he was instrumental in its creation.

Store and Dance Hall, Island Pond, N. H.

Stores, restaurants, and dance halls lined sections of the lakes and ponds in the early 1900s. On Sunset Lake at Ells Shore, Ethel Ells ran a small store and restaurant in the 1930s and 1940s. The dancehall pictured here was one of the many sites along Island Pond's shores that Isaac Randall had made into postcards to sell at his general store. (Courtesy of Jim Wilkinson.)

Five

HAMPSTEAD PRIDE

Civic duty has been a throughline of Hampstead since its earliest days. Upon incorporation in 1749, a board of five selectmen was chosen to oversee the newly formed Hampstead, consisting of John Johnson, Peter Morse, George Little, Jacob Bailey, and Stephen Johnson. Other elected positions included moderator, town clerk, constable, and hogreeve, an official position in charge of rounding up stray hogs. A sense of civic responsibility was seen not only in elected capacity, but in the many volunteers who kept Hampstead running. From the town's inception up until 1938, fires were fought by a so-called volunteer bucket brigade, with help being summoned from other towns when the Meeting House bell rang as an alarm. Hampstead also has a long history of military service, although records were imperfect regarding exact counts, as they came from multiple sources. In June 1775, after meeting with Capt. Hezekiah Hutchens at the local Harriman's Tavern, 35 men from Hampstead marched south to battle at Bunker Hill, and from 1775 until 1781, during the Revolutionary War, there were 110 men serving in places like Trenton and Saratoga. The 6th Company of the 7th Regiment of New Hampshire Militia was formed in Hampstead at the end of the War of 1812 in which 15 men fought. Later, 79 men fought in the Civil War, with one being awarded the Medal of Honor, 25 in World War I, and over 100 men and women served in World War II. Gravestones from those who served as far back as the French and Indian War can be found in Hadley Cemetery. During the winter of 1848, it was decided that the town would put together a celebration for Hampstead's 100th anniversary the following year, and the town has celebrated our founding every 25 years since 1899.

Linus Hale Little, the son of Linus L.C. Little and Abiah Tewksbury Little, was born in Hampstead on September 28, 1839, and served in the 11th New Hampshire Infantry from August 12, 1862, until June 3, 1865. He was captured at the Battle of the Crater in Petersburg, Virginia on July 30, 1864, and was in a prison camp in Danville, Virginia, for nearly a year after being captured by the Confederate army. During his imprisonment, he passed time carving trinkets such as a spoon and mirror case that are preserved at the Hampstead Historical Society. He later became a shoemaker and carpenter and married Tryphena Jefferson. The Little family has a long military history. His father, Linus L.C. Little, was captain of a military company, and his great-grandfather Nathaniel Little fought in the Revolutionary War and, according to Harriette E. Noyes, had his "coat riddled with bullets while in the thickest of the fight at Saratoga, but escaped himself without a scratch."

Both the 100th-anniversary celebration in 1849 and the 150th-anniversary celebration in 1899 were celebrated on the shore of Wash Pond. In 1849, Hoyts Grove was chosen as the location, which was at the end of what is now Timberlane Road. By 1899, this parcel of land was renamed Bricketts Grove.

The 175th-anniversary two-day celebration in 1924 was held in various locations around town. On the first day, Sunday, attendees were encouraged to check in and sign the guest books located at the library and were invited to a luncheon at a resident's house after morning church services at the Congregational Church.

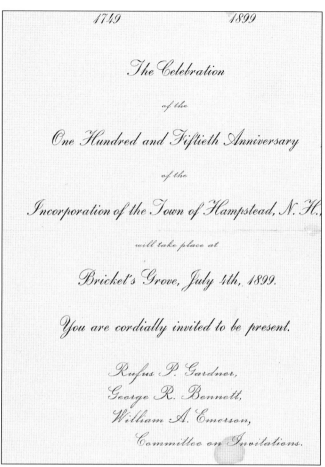

1749 *1899*

The Celebration

of the

One Hundred and Fiftieth Anniversary

of the

Incorporation of the Town of Hampstead, N. H.,

will take place at

Bricket's Grove, July 4th, 1899.

You are cordially invited to be present.

Rufus P. Gardner,
George R. Bennett,
William A. Emerson,
 Committee on Invitations.

The second day of the 175th-anniversary celebration included a band performance, followed by addresses from town officials and letters read from those who could not attend in person (including Sarah T. Gage of West Hampstead who, at 102 years old, was the oldest resident in town). The day was also filled with a full program of sports events played on Emerson Field behind the high school. First and second prizes went to those competing in the activities, including the 50-, 75- and 100-yard dash, the standing and running jump, climbing of a greased pole, and running down and capturing a greased pig. The day concluded with fireworks and a dance at the Meeting House.

The bronze Hampstead Civil War monument titled "Statue of the American Soldier" was dedicated on Memorial Day in 1906 after the town's usual holiday celebrations and was erected in honor of, and names 79 Hampstead men who fought in the Civil War. It was decided the previous year that the town would spend $1,000 to erect the monument, which was made of a granite boulder that weighed some 50 tons, of a life-sized statue of a soldier and a bronze tablet to list the names. During the dedication ceremony, the statue was presented to the town by Dr. George Bennette, Andrew Moulton accepted the statue on behalf of Hampstead, while the Reverend W.H. Woodsum and Moody Brickett made remarks on behalf of the veterans who were unable to attend. The last two Civil War veterans from Hampstead, Abiah Hutton and Charles Stevens, died in 1931 and are buried in Lakeview Cemetery.

The first Boy Scout troop in town was started in West Hampstead and led by Reverend Collins of the West Hampstead Methodist Church. From left to right are unidentified, unidentified, Philip Darling, Maurice Lake, Leland Fitts, Oscar Wait, Frank E. Howard, Everett Mills, Dexter Buchanon, and Reverend Collins. (Courtesy of Eric Howard.)

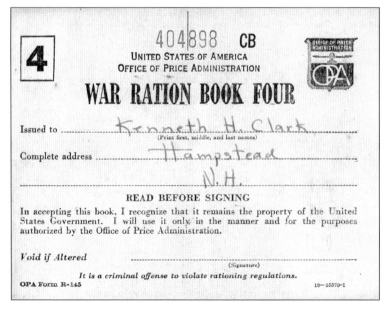

This "War Ration Book Four," issued to Kenneth H. Clark, was distributed in late 1943. When the United States officially entered World War II, shortages of essential materials, fuel, and sugar were expected; therefore, the US Office of Price Administration began issuing ration books. (Courtesy of Karen Clark Turcotte.)

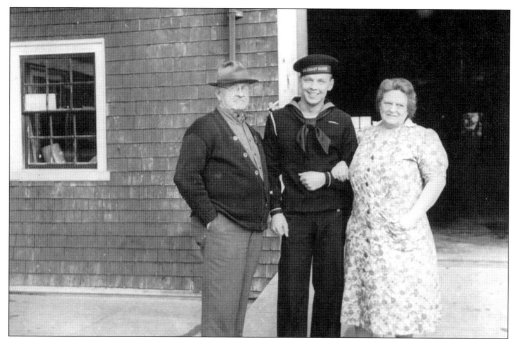

From left to right are Charles Littlefield II, Charles Littlefield III, and Caroline Jewell Littlefield. The family is standing in front of their barn, and Charles III is seen in his Coast Guard uniform before he left for duty. In 1942, he enlisted in the Coast Guard and served in the Caribbean where he was a radioman first class. (Courtesy of the Brickett family.)

From left to right are (first row) Gene T. Duston and Donald L. Duston; (second row) Ralph E. Brickett, Virginia F. Duston Brickett, and Leslie W. Duston. The Duston siblings pictured in 1946 were the children of Levi and Myrtis Duston. Virginia Duston and Ralph Brickett were married the year before this photograph on April 7, 1945, while they were both on active military duty during World War II.

Each Memorial Day after church services, a parade would form behind the parade marshal and veterans, which included a band, the Boy Scouts, various women's groups, and schoolchildren holding American flags. They would head down Main Street to the Civil War monument, on to the World War II monument in front of the high school, and loop back to the library's front lawn, where the World War I monument stood. When they reached this endpoint, a wreath was laid. The parade was followed by a band performance, where relatives and friends who had come to town to decorate graves and pay their respects would gather with residents.

THREE DAYS OF

Celebration

FREE *ON THE MIDWAY* **FREE**

Auto Show - Farm Equipment Show - Boat Show

Home Appliance Show - Music . Games - Novelties

AT TOWN HALL

Antique Display - Arts and Crafts - Television

── *SPECIALTIES* ──

Friday, August 12th

10:00 A. M. to 5:00 P. M.
At Ball Field
FIELD SPORTS

8:30 P. M. to 9:30 P. M.
On Midway
STAGE SHOW
CONTINUOUS MOVIES AFTER DARK

7:30 P. M. to 11:30 P. M.
DRAWING EVERY HOUR

Saturday August 13th	Sunday, August 14th
10:00 A. M. **HUGE PARADE**	10:00 A. M. At Hampstead Congregational Church Holy Angels Catholic Church **CHURCH SERVICE** (Special Music)
12:00 Noon At Town Hall **GOVERNOR'S LUNCHEON** (Make reservations)	12:30 P. M. to 2:00 P. M. On High School Lawn **DINNER** (Make reservations)
1:30 P. M. to 2:30 P. M. On Midway **GUEST SPEAKERS** (National — State — County)	2:30 P. M. to 6:00 P. M. At Sunset Lake **WATER SPORTS — AQUABELLES** **AIR SHOW**
6:00 P. M. to 7:00 P. M. At Town Hall **SUPPER** (Make reservations)	7:30 P. M. to 9:30 P. M. On Midway **BAND CONCERT**
3:30 P. M. to 11:30 P. M. On Midway **DRAWING EVERY HOUR** **CONTINUOUS MOVIES AFTER DARK**	9:30 P. M. **FIREWORKS**

For Reservations and Information contact R. J. Rooney, Hampstead, N. H.

HAMPSTEAD, N. H.

200th ANNIVERSARY

Over 300 former residents returned to Hampstead to take part in the town's bicentennial festivities. In addition to events shown on the flyer, 12 planes from Grenier Army Airfield flew over the parade circling north to south three times, there was a display of photographs from Hampstead, England, for people to enjoy, and a display of television sets at town hall to give people the "opportunity of seeing the sets in actual use." Attendees were surprised on Saturday evening at the television exhibit when they saw the Hampstead parade being broadcast over Channel 4 in the evening newsreel. It was reported to be the first parade from New Hampshire to be televised. The Friday field sports games for children and the Sunday water aquacade performance were both canceled due to a suspected case of polio affecting a visiting family member at Sunset Lake. These cancellations prompted Tel Noar Lodge to host a last-minute event to replace the canceled water performance, so a program of dancing and singing took place at their lodge.

Clinton Buttrick was parade marshal for the town's 200th anniversary celebration in 1949. He led the two-mile-long parade down Main Street where, in front of the high school, the reviewing committee of local officials and Gov. Sherman Adams were perched on a stand. There were so many people in the parade that Buttrick crossed the finish long before the last float even left the starting point. (Courtesy of Bonnie Howard Knox.)

Peggy Shattuck (right) dressed up as Miss Sunset Lake for the 200th-anniversary parade in a Mae West–inspired outfit and rode on cushions in a car they called the "Green Hornet." She was not actually a crowned beauty queen but masqueraded as one while impersonating "a belle of a bygone day." She was a resident of Sunset Lake and was driven by Joseph Vargus.

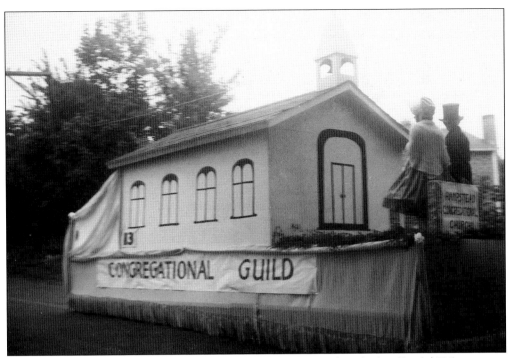

The main attraction of the three-day celebration was the parade, which offered $225 in prizes. There were nearly 100 entries of floats, individual displays, and horseback riders who were judged on their originality and a separate category for humor. The newspaper excitedly announced that even Miss New Hampshire would participate in the parade, but she arrived late and instead gave remarks at an event later in the day. The float by the Congregational Church (above) featured a miniature white church with a steeple and bell. Sitting in front of the church were two children, Caroline Ells and Allan Clark, who dressed in old-fashioned clothes. This float won an honorable mention ribbon. The Hampstead Grange (below), formed on May 4, 1891, also participated with a float that reads, "The Farmer Feeds Them All."

The parade included 142 entries from members of veteran, civic, and military organizations. The military division that headed the parade was made up of 100 marching airmen and four officers from Grenier Airfield, Manchester, and a marine detachment of 40 men from Portsmouth Navy Yard. Behind them was the communication system truck from the first naval district headquarters in Boston.

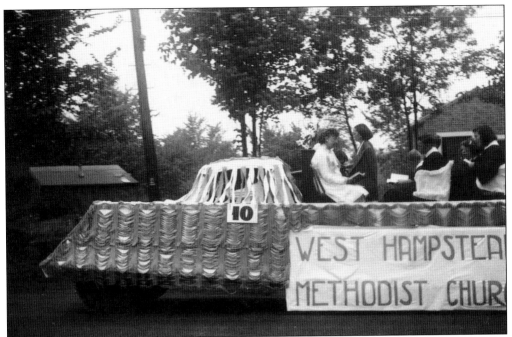

The West Hampstead Methodist Church created a float to represent the interior of a church scene. As it made its way down the parade route, the church's choir sat in rows, singing old hymns, and was accompanied by an organist.

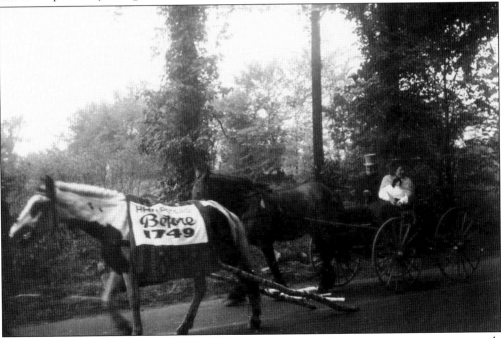

With Hampstead celebrating the 200th anniversary since its incorporation, some parade participants gave a nod to the past. A newspaper article pointed out the delight people felt when they saw old horse-drawn wagons carrying couples dressed in clothing of an earlier era, with one such couple even carrying an old hand pump that was once used to fight fires.

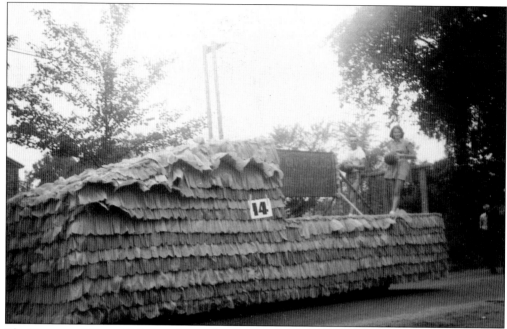

The Hampstead Civic Club float featured Dorothy Mansur (right) of the Hampstead High School girls' basketball team and Huxley White of the boys' basketball team, both in their uniforms. This float was modeled to look like a basketball court and won honorable mention.

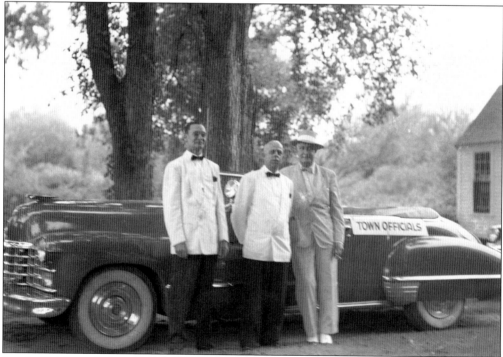

Local officials, including the board of selectmen, rode in the parade and then joined the judges and state officials on the reviewing stand near the high school to observe the parade participants. It was there that Ralph Rooney Sr., the chairman of the anniversary celebration, gave out the awards.

At noon after the parade concluded the Hampstead Grange hosted a governor's luncheon, attended by Governor Adams. It was held in the Hampstead Central School and Hampstead Town Hall. Also attending were Senators Charles W. Tobey and Styles Bridges and Congressman Chester E. Morrow. All gave speeches, with Adams stating that all Hampstead residents should resolve that day that in the next 50 years, 150 years, or 200 years, those who gather here shall gather in a community as beautiful, quiet, and lovely as this community is today. The luncheon ran from 12:30 p.m. until 2:00 p.m. and cost $2 to attend. The governor's speech along with the service at the Congregational Church was broadcast over the WHAV radio station.

The decorating committee for the celebration was led by chairman Jonathan Wentworth, Abbie Randall, Marianna Ayer, Maurice I. Randall Sr., and Kenneth Duston. $474.68 from the $4,190.34 budget was spent on publicity and decorations, with the task of decorating buildings around town being completed by Phillips Decorating Services in Millbury, Massachusetts. Anyone wishing to have their home decorated was to get in touch with decorating chairman Wentworth, and in the days before the celebration private homes, businesses, and town buildings were embellished with flags and other celebratory adornments to spread the festivities across town. (Both, courtesy of Eric Howard.)

The formation of the Hampstead Volunteer Fire Protection Association in the spring of 1938 highlighted the need for stronger protective measures, and the next year, it was voted to purchase a fire truck with a vote to build the central firehouse three years later. In 1948, the fire department added a new 500-gallon tank truck thanks to the help of the Civic Club, the Firemen's Association, and the town. From left to right in the image above are (first row) Dan Gaskill, Mike Darling, Frank E. Howard, John Hutton Jr., Fred Hutton, Paul Covell, Jerry Johnson, and fire chief Roland True; (second row) Bob Webster and Warren Ells. In 1952, a Red Network system consisting of five phones in different houses was installed to be used for a fire emergency, and those answering were tasked with rounding up the firefighters on the call list.

The members of the 1955 Hampstead Police Department fielded 96 calls, including responding to accidents, out-of-state summonses, and loose goats. They also formed a relief association for the betterment of the department and the relief of any disabled members. From left to right are (first row) Charles Estabrook, Frank Clough, R. Arthur Johnson (police chief), and Frank C. Howard (deputy chief); (second row) Jonathan Wentworth, Lester Remick, Russell Hall, and Earl Demeritt.

Pictured here is John O. Parlin of the Hampstead Police Department. As early as 1749 a constable was hired by the town, making it one of the first elected positions after Hampstead received its charter, and 13 men followed in that role until the first chief of police was appointed in 1919, which led to the position of constable being phased out in 1930.

A member of the Veterans of Foreign Wars (left) presents William Letoile with a certificate of appreciation for the Hampstead Police Department. Letoile was appointed to the police force in 1962 and elected chief in 1970. He was a veteran of the Army and former president of the Hampstead Civic Club. As police chief, Letoile created a full-time police force and established a police headquarters, which had previously been informally run out of the police chief's home.

The first Hampstead Police Department patrol car was presented to the department by the Hampstead Lions Club at the annual Memorial Day services in 1968. Police chief Kenneth Clark accepted the vehicle, a 1968 Plymouth Wagon, which was equipped as a police cruiser and an ambulance. It was housed at the Central Fire Station. (Courtesy of Karen Clark Turcotte.)

The 1953 Civil Defense Unit, pictured from left to right, are (first row) Ted Hadley (director), Eva Rooney (clerk), and Ralph Rooney Sr. (past director); (second row) Jonathan Wentworth (selectman), Doris Spollett (selectman), Joseph Demasky (state police officer), Kenneth Duston (fire chief), R. Arthur "Jerry" Johnston (police chief), and Edmund "Duffy" Lewis (director of transportation). This gathering took place after the first statewide test Red Alert sounded at 1:31 p.m. on January 24, and a practice air raid plan was executed in town, led by the Civil Defense Unit. When the alarm went off, those pictured, and 48 other local members of the Civil Defense Unit, responded and went to their posts across town where they stopped traffic and cleared the streets. The group also included a partnership with the high school, which furnished messengers to notify people who may be out of earshot of the siren or in case telephones were out of operation. These efforts were coordinated at a state level.

From left to right sit Jonathan Wentworth, Edmund Lewis, Wendall B. Wyatt (chairman), Charles Martin, and Arnold Rivers, all members of the 1956 planning board along with George Chase who is not pictured. This group was appointed by the selectmen, and they met the last Sunday of each month at 8:00 p.m. on the second floor of the firehouse. That year, their priorities focused on what they called the chaos of a building boom happening in Southern New Hampshire. They were concerned with protecting drinking water from pollution created by the increase in new home septic tanks and recommended people test their water once a year. There were 10 approved plot plans for residential building, and the board urged landowners to consider subdividing parts of their property that sat idle and sell them for the welfare of town taxes. They also recommended the town hire a building inspector to help assist builders in the details of new constructions.

Town clerk Charles Brooks is pictured at his work desk in 1956. Brooks was the person townspeople turned to for everything including marriage licenses, birth certificates, death certificates, and license plates. He worked out of the foyer in the front of his home, and people just walked in his door when they needed his services. He lived on Stage Road, with the hill going down to his house informally called "Brooks' Hill."

On September 11, 1975, Pres. Gerald Ford visited Hampstead. From left to right are Gov. Meldrim Thomson, Jr., Congressman Louis Wyman, Pres. Gerald Ford, Charles Lindquist, and Dean Howard. Lindquist and Howard were selectmen of Hampstead at the time, and they, along with Selectman Laurence Cornwell, presented President Ford with a silver coin and a Paul Revere bowl to commemorate the 225th anniversary of Hampstead. (Courtesy of the Howard family.)

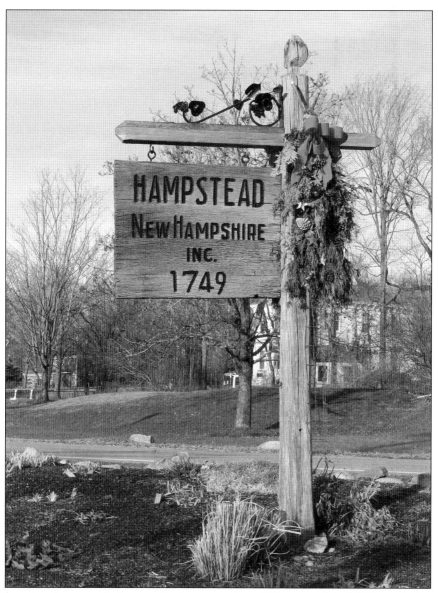

A wooden sign that proudly honors the incorporation of Hampstead in 1749 was designed and built by Walter "Chip" Hastings and Robert Letoile in 1971 on behalf of the Civic Club. The Garden Club has maintained the flowers around the sign since 1984, while countless people—both longtime residents and those simply passing through—have enjoyed its evocation of the past. An article celebrating its installment called the sign "a focal point in Hampstead and a symbol of the strong civic pride and community spirit that flows through this town." It sits on a 1,300-square-foot grassy area on Main Street, which is now called Sign Island, and is within the sightline of the Meeting House, where the first town meeting was held. In her address on the 100th anniversary, historian Harriette E. Noyes hoped future generations would "search deeper into the history, legends and personal acts of the town builders, preserving with zeal and enthusiasm" and feel "the pioneers of Hampstead, chose for their inheritance the most goodley land and the most wise precepts." On Hampstead's 275th anniversary, her wish has been honored with this curated collection of images to share that message with a new generation.

DISCOVER THOUSANDS OF LOCAL HISTORY BOOKS FEATURING MILLIONS OF VINTAGE IMAGES

Arcadia Publishing, the leading local history publisher in the United States, is committed to making history accessible and meaningful through publishing books that celebrate and preserve the heritage of America's people and places.

Find more books like this at
www.arcadiapublishing.com

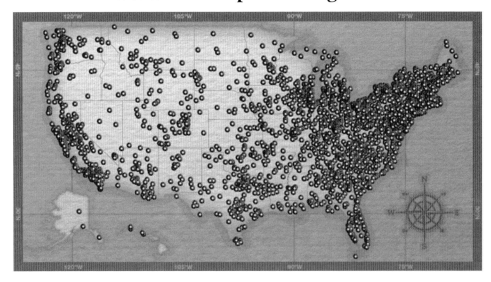

Search for your hometown history, your old stomping grounds, and even your favorite sports team.

Consistent with our mission to preserve history on a local level, this book was printed in South Carolina on American-made paper and manufactured entirely in the United States. Products carrying the accredited Forest Stewardship Council (FSC) label are printed on 100 percent FSC-certified paper.